CW00558489

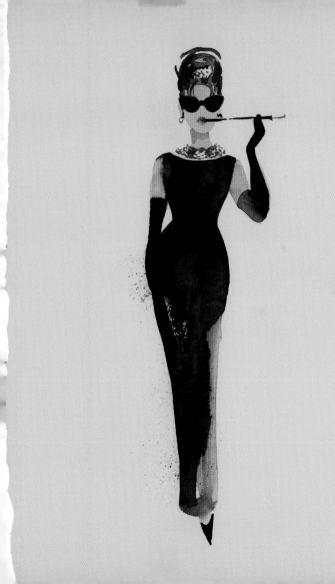

ICONS OF STYLE

AUDREY HEPBURN

Harper *by* Design

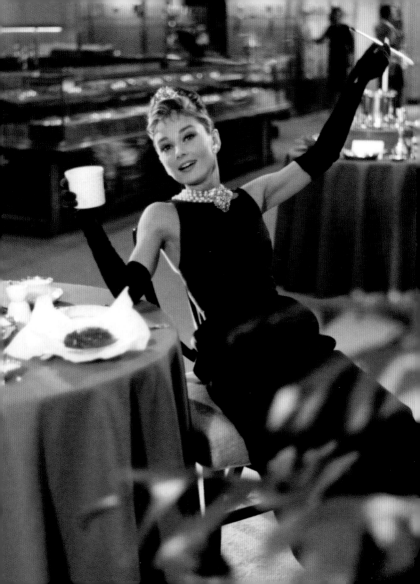

EVERY DAY, YOU SHOULD HAVE ONE EXQUISITE MOMENT.

TRUE BEAUTY IN A WOMAN IS REFLECTED IN HER SOUL.

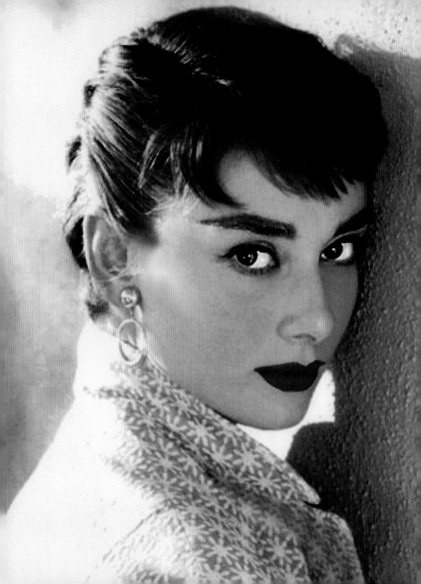

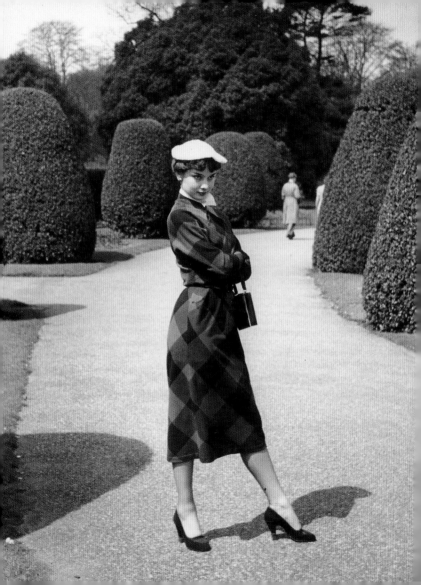

NOTHING IS IMPOSSIBLE; THE WORD ITSELF SAYS 'I'M POSSIBLE!'

I BELIEVE IN OVERDRESSING.

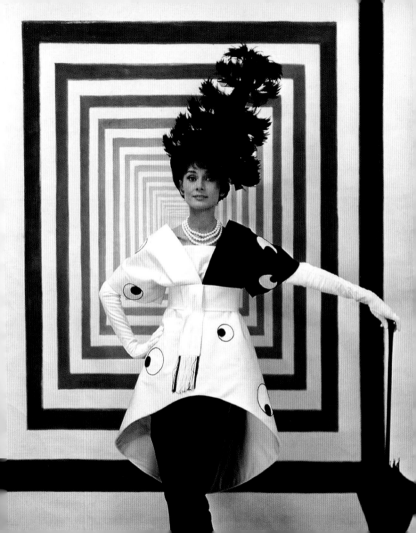

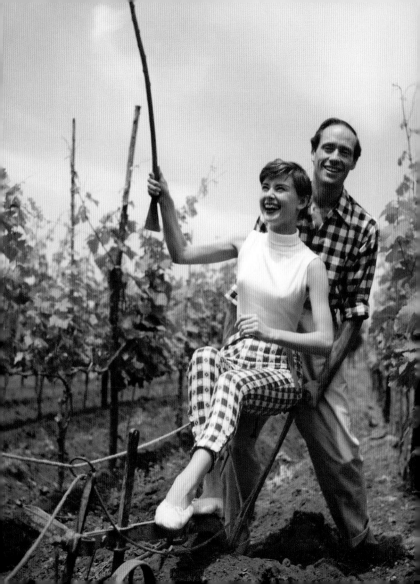

THE BEST THING TO HOLD ONTO IN LIFE IS EACH OTHER.

PICK THE DAY.
ENJOY IT –
TO THE HILT.

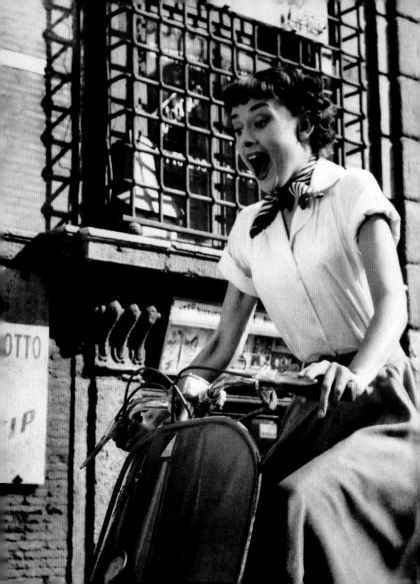

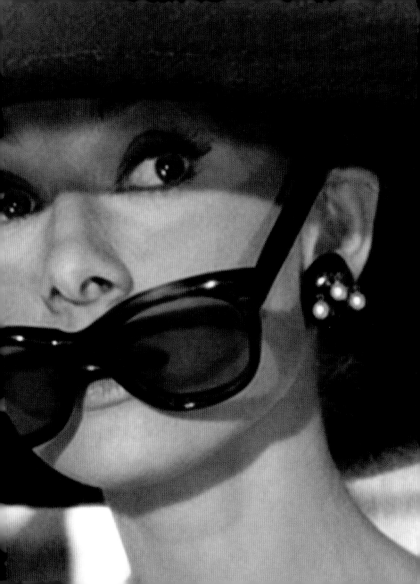

NO AMOUNT OF MAKEUP CAN COVER AN UGLY PERSONALITY.

WALK WITH THE KNOWLEDGE THAT YOU ARE NEVER ALONE.

HAPPINESS IS HEALTH AND A SHORT MEMORY!

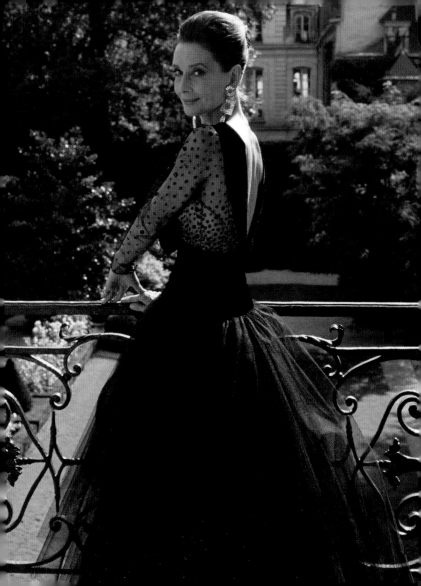

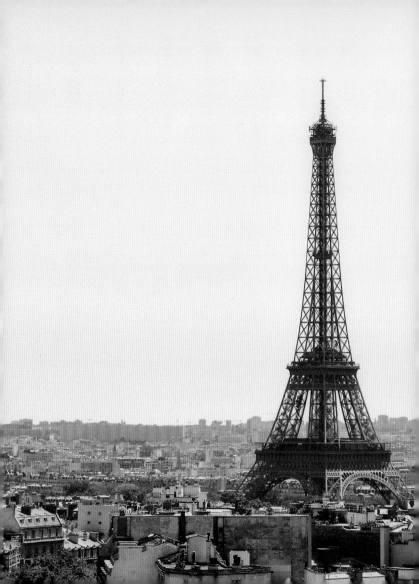

PARIS IS ALWAYS A GOOD IDEA.

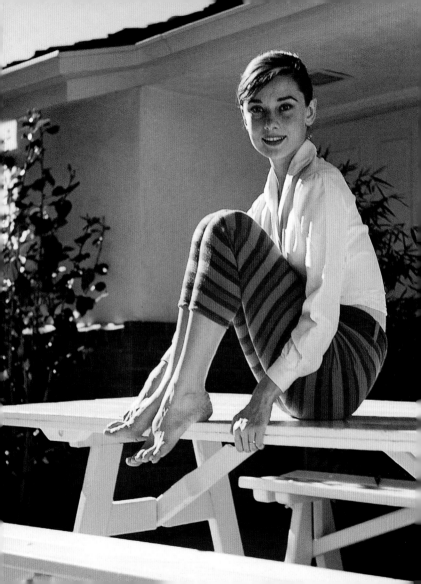

EVERYONE HAS HIS OWN STYLE. WHEN YOU HAVE FOUND IT, YOU SHOULD STICK TO IT.

A WOMAN CAN BE BEAUTIFUL AS WELL AS INTELLECTUAL.

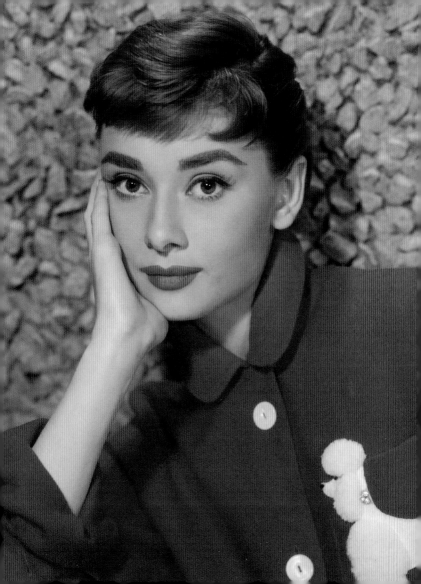

THE BEAUTY OF A WOMAN IS SEEN IN HER EYES.

I TAUGHT HER HOW TO CUSS AND SHE TAUGHT ME HOW TO DRESS.

Shirley MacLaine

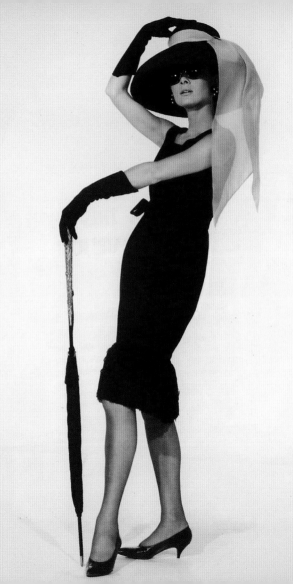

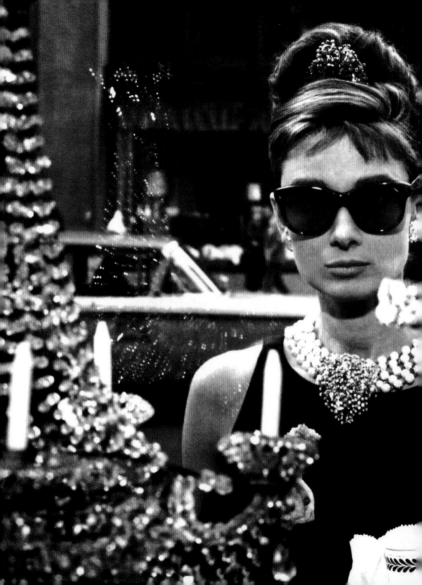

LOOK FOR THE GOOD IN OTHERS.

THE ONLY THINGS OF INTEREST ARE THOSE LINKED TO THE HEART.

YOU HAVE TWO
HANDS: ONE
FOR HELPING
YOURSELF, THE
OTHER FOR
HELPING OTHERS.

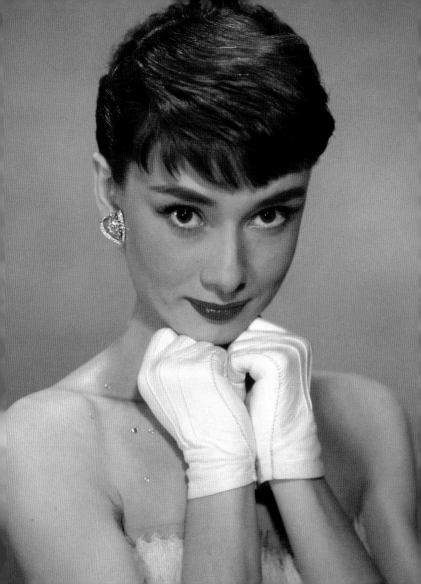

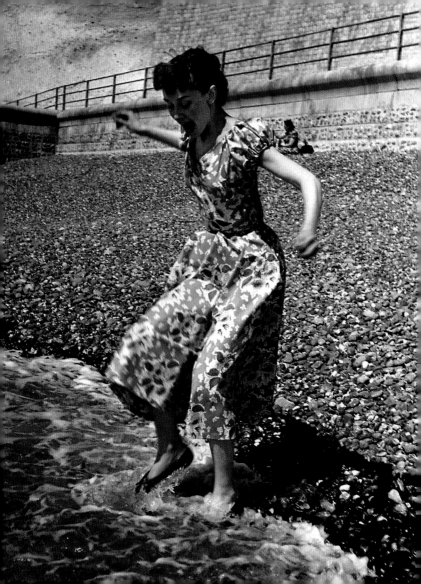

I LOVE PEOPLE WHO MAKE ME LAUGH.

LIFE IS A PARTY.

DRESS FOR IT.

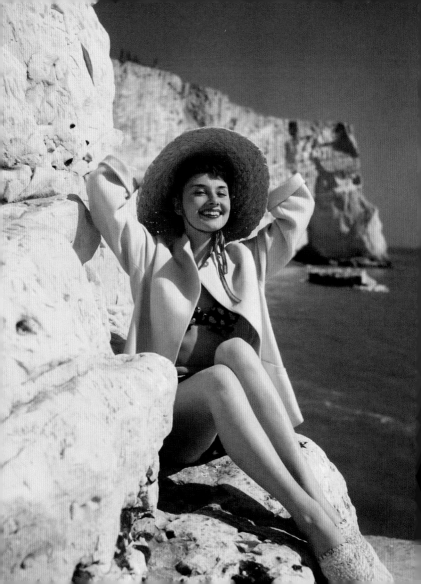

HAPPY GIRLS ARE THE PRETTIEST GIRLS.

A WIDE-EYED DOE PRANCING THROUGH THE FOREST.

Billy Wilder

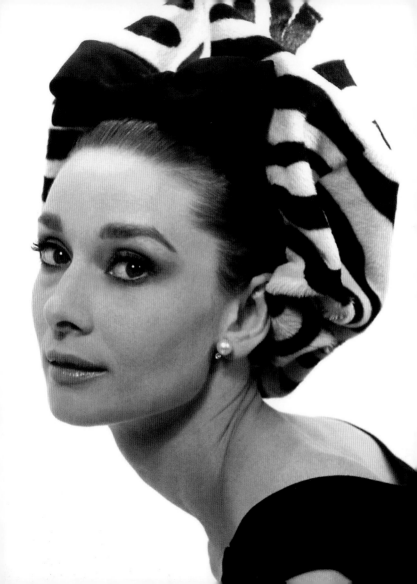

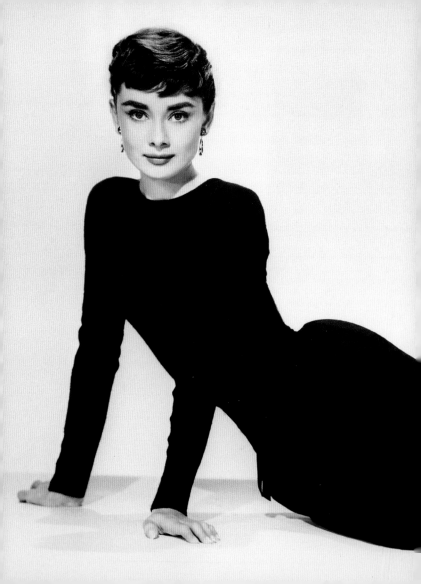

THERE IS MORE TO SEX APPEAL THAN JUST MEASUREMENTS.

LOVE IS THE BEST
INVESTMENT;
THE MORE YOU
GIVE, THE MORE
YOU GET.

LIVING IS LIKE TEARING THROUGH A MUSEUM ... YOU CAN'T TAKE IT ALL IN AT ONCE.

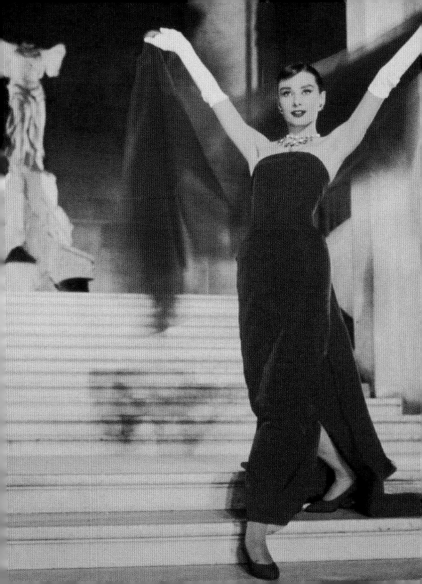

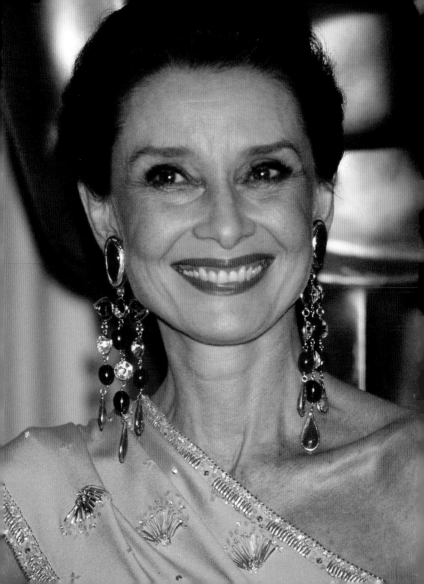

THE BEAUTY OF A WOMAN GROWS WITH THE PASSING YEARS.

HER CLEARLY RECOGNISABLE LOOK – WHAT I LIKE TO THINK OF AS A SOPHISTICATED ELF.

Gregory Peck

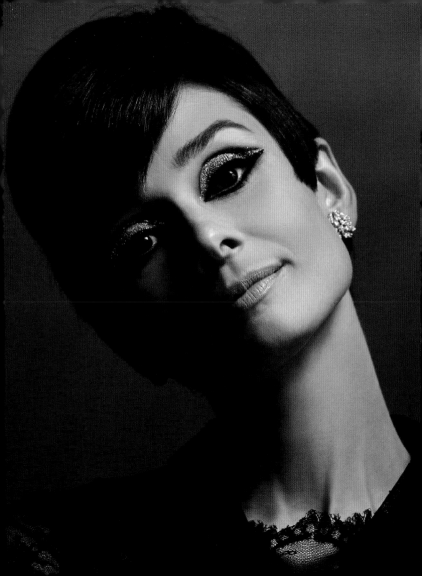

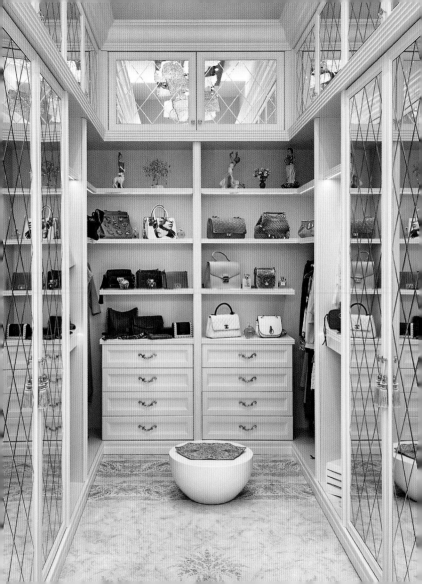

SOME PEOPLE
DREAM OF HAVING
A BIG SWIMMING
POOL. WITH ME,
IT'S CLOSETS.

ENJOY YOUR LIFE – TO BE HAPPY, IT'S ALL THAT MATTERS.

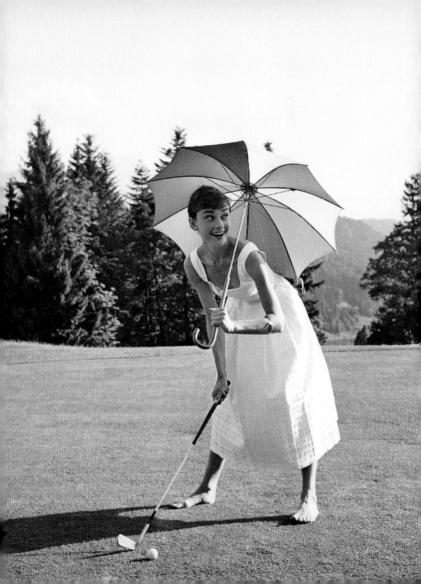

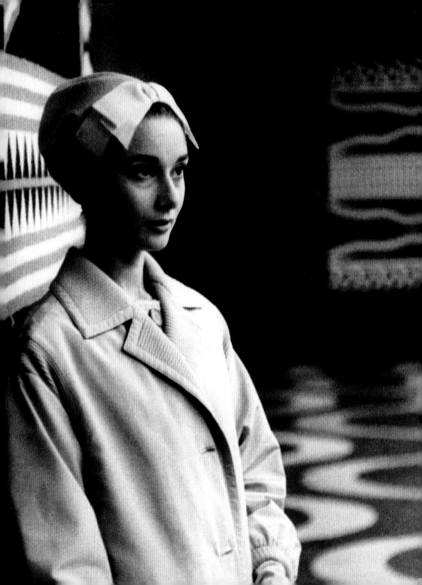

THERE ARE
CERTAIN SHADES
OF LIMELIGHT
THAT CAN
WRECK A GIRL'S
COMPLEXION.

I FOLLOWED MY INSTINCTS AND THEY'VE BROUGHT ME NOTHING BUT BLESSINGS AND GOOD FORTUNE.

SPEAK ONLY WORDS OF KINDNESS.

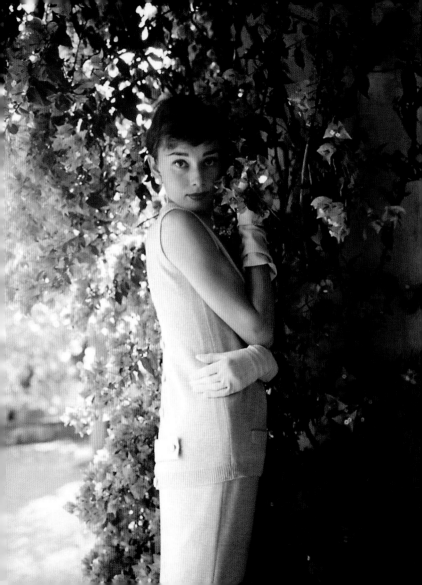

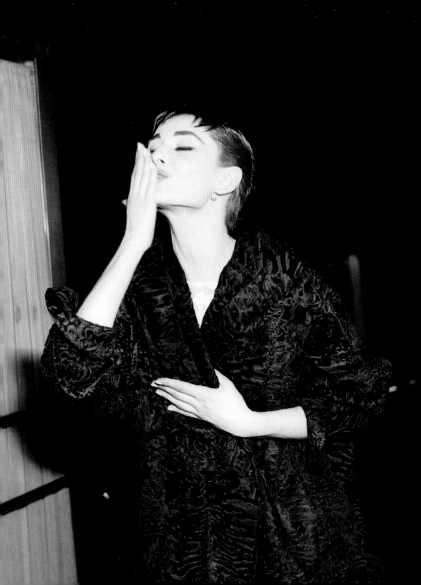

KISS SLOWLY.

LOVE TRULY.

I BELIEVE IN BEING STRONG WHEN EVERYTHING ELSE SEEMS TO BE GOING WRONG.

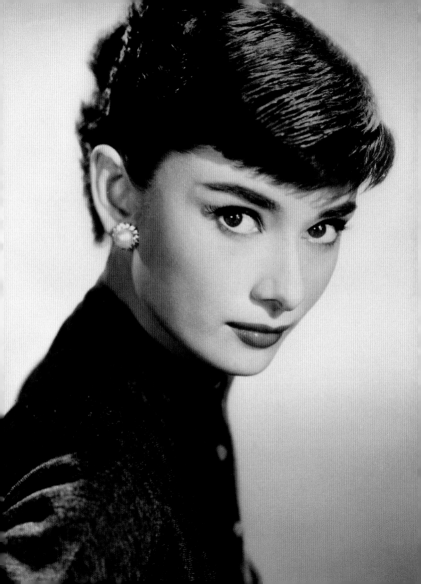

I DON'T THINK
THERE WAS A
SOUL WHO DIDN'T
LOVE HER.

Julie Andrews

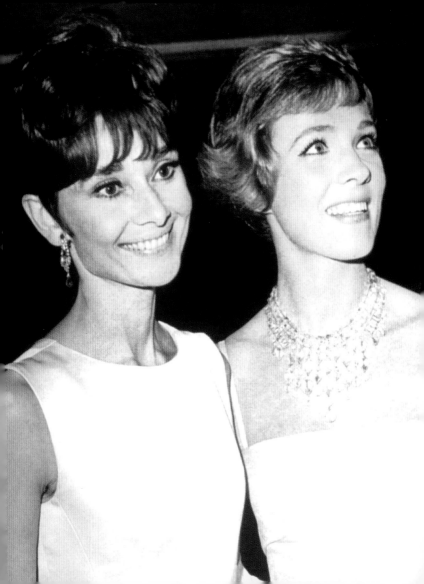

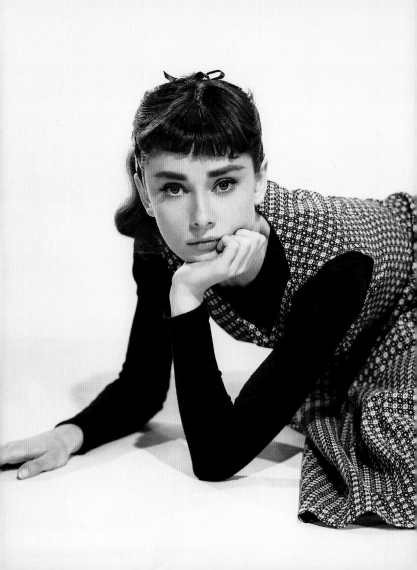

THE GREATEST VICTORY HAS BEEN TO BE ABLE TO LIVE WITH MYSELF.

LAUGHING CURES A MULTITUDE OF ILLS.

I DON'T TAKE MY
LIFE SERIOUSLY,
BUT I DO TAKE
WHAT I DO IN MY
LIFE SERIOUSLY.

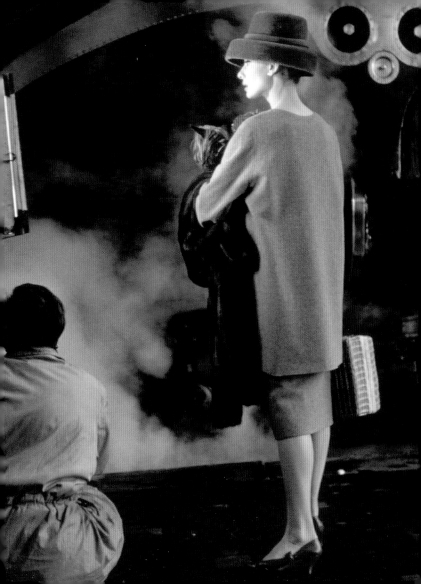

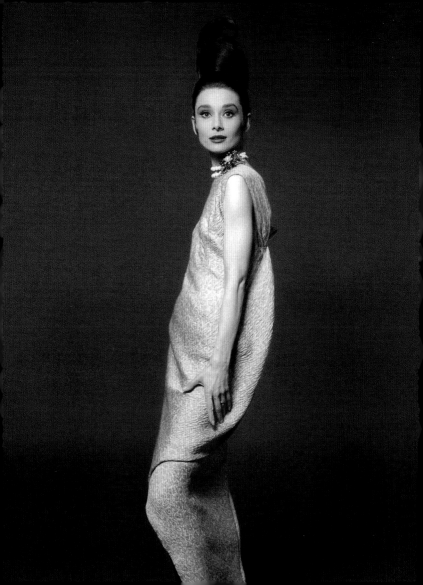

I CREATED A LOOK IN ORDER TO MAKE SOMETHING OF MYSELF.

SHE COMPLETELY LOOKED THE PART OF A PRINCESS. A REAL, LIVE, BONA FIDE PRINCESS.

William Wyler

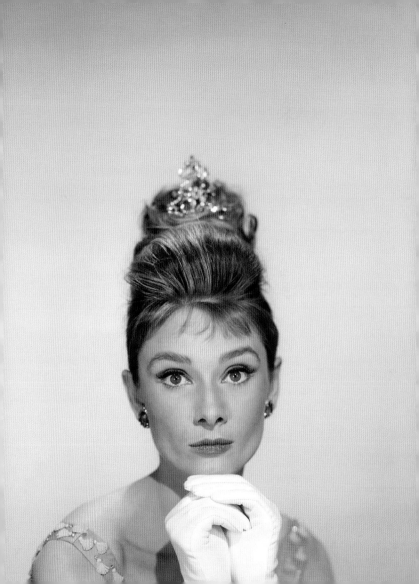

TREASURE THE
DAY ... JUST HOW
WONDERFUL IT
IS SIMPLY TO BE
ALIVE AT ALL.

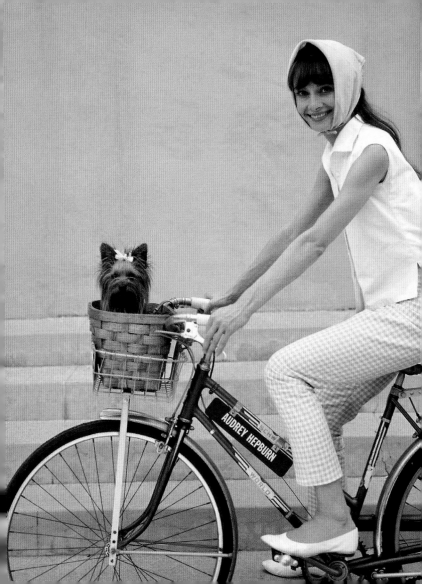

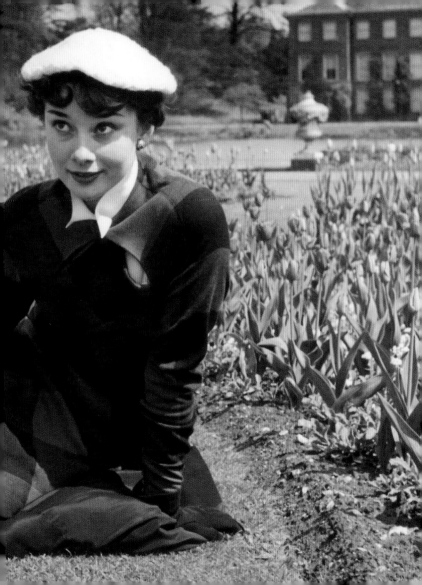

TRUE FRIENDS
ARE FAMILIES
WHICH YOU
CAN SELECT.

FORGIVE QUICKLY.

LAUGH
UNCONTROLLABLY
AND NEVER
REGRET ANYTHING
THAT MADE
YOU SMILE.

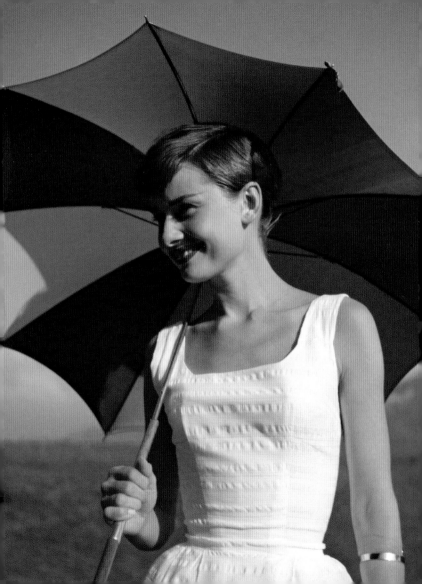

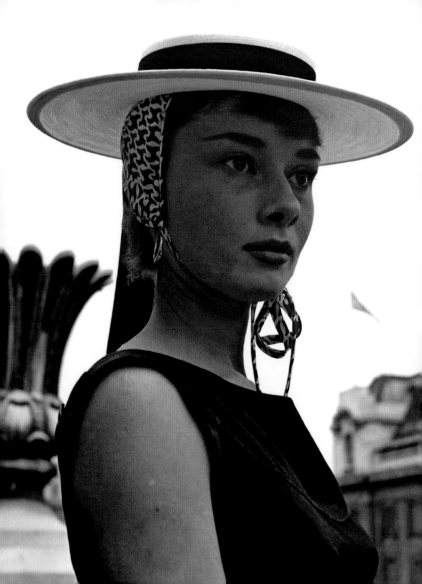

SHE DIDN'T GO WITH THE TRENDS, DIDN'T REINVENT HERSELF EVERY SEASON.

Sean H. Ferrer

I STILL READ FAIRY TALES, AND I LIKE THEM BEST OF ALL.

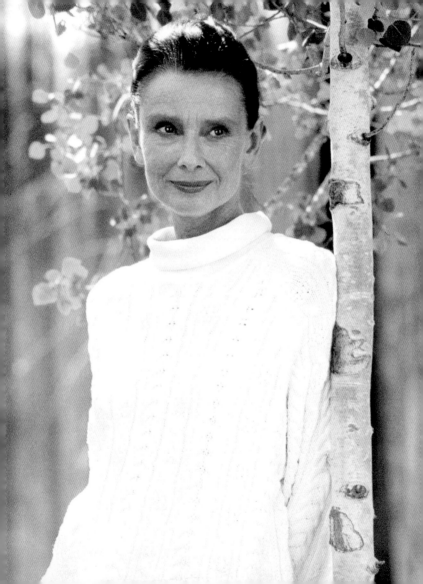

ELEGANCE
IS THE ONLY
BEAUTY THAT
NEVER FADES.

Harper *by* Design

An imprint of HarperCollins*Publishers*

HarperCollins*Publishers*
Australia • Brazil • Canada • France • Germany • Holland • India
Italy • Japan • Mexico • New Zealand • Poland • Spain • Sweden
Switzerland • United Kingdom • United States of America

HarperCollins acknowledges the Traditional Custodians of the land upon which we live and work,
and pays respect to Elders past and present.

First published in Australia in 2023
by HarperCollins*Publishers* Australia Pty Limited
Gadigal Country
Level 13, 201 Elizabeth Street, Sydney NSW 2000
ABN 36 009 913 517
harpercollins.com.au

A catalogue record for this book is available from the National Library of Australia

ISBN 978 1 4607 6383 4

Publisher: Mark Campbell
Publishing Director: Brigitta Doyle
Project Editor: Barbara McClenahan
Designer: Mietta Yans, HarperCollins Design Studio
Illustrator: Gypsy Taylor
Photography by Album / Alamy Stock Photo: 65; All Star Picture Library / Alamy Stock Photo: 7; Archive Photos via
Getty Images: 12, 51, 89; Asar Studios / Alamy Stock Photo: 78; Bert Hardy via Getty Images: 8, 77; Bettmann via Getty
Images: 15, 46–7, 66, 69; CBS Photo Archive via Getty Images: 16–17; Donaldson Collection via Getty Images: 4, 11,
32–3; Douglas Kirkland / Corbis Premium Historical via Getty Images: 55; Hulton Archive via Getty Images: 28, 31, 37,
59, 71, 84–5; iStock: 22, 93; John Kobal Foundation via Getty Images: 72–3; John Springer Collection via Getty Images:
81; Maureen Donaldson via Getty Images: 52; Mondadori Portfolio via Getty Images: 60–1; Pictorial Press / Alamy
Stock Photo: 45, 83; Popperfoto via Getty Images: 38, 42, 90; SAUER Jean-Claude / Paris Match via Getty Images: 20;
Shutterstock: back cover, title page, 27, 41, 56; Sunset Boulevard via Getty Images: 24; United Artists / Courtesy Everett
Collection / Alamy Stock Photo: 94
Colour reproduction by Splitting Image Colour Studio, Wantirna VIC
Printed and bound in China by 1010 Printing

8 7 6 5 4 3 2 1 23 24 25 26